Skeptical Verse

1995-2008

T0148347

Skeptical Verse

1995-2008

Raoul A. LeBlanc

iUniverse, Inc.
New York Bloomington

SKEPTICAL VERSE 1996-2008

iUniverse books may be ordered through
booksellers or by contacting:

iUniverse
1663 Liberty Drive
Bloomington, IN 47403
www.iuniverse.com
1-800-Authors (1-800-288-4677)

ISBN: 978-1-4401-1379-6 (pbk)
ISBN: 978-1-4401-1380-2 (ebk)

Library of Congress Control Number: 2008944242

Cover Design: Raoul A. LeBlanc

Printed in the United States of America
iUniverse rev. date: 01/22/2009

Contents

Acknowledgments

At age fifteen, I found poetry aboard the G. S. Grenville, a Canadian buoy and lighthouse service vessel and ice breaker on the lower Great Lakes and the Saint Lawrence River. It was a book of poems by Robert Burns.

Since poetry has been one of my favorite reading subjects which has included most ot the poets of the 19th and 20th centuries as well as many recent ones, to whom I am indebted for whatever inspiration that has been mine. As well I am indebted to the many friends that have read or listened to my poems and have encouraged me to continue writing.

In the early 1950's two of my poems were published in an Anthology of Modern American Verse, a number have been published by the International Library of Poetry, including my being featured in their International Who's Who in poetry in 2004. A few of my poems have been published by Noble House Publishers, London, UK.

SPELUNKING

Under the long dead sea
under the musty ground
in the dark damp ground
in the hard rock sea

Where she followed me
on the cold mud floor
where no one before
had left any sign
of human design

1-20-1996

ONE OR TWO

A million or two
would be very nice
to pay the price
of things to do
to enhance your life
entice a wife
or if you like
fly yourself a kite

1-20-1996

WOULD PREFER

Not to a grave
but to a silent glade
where magpies
could eat my eyes
and carrion crows
could eat my toes

The ravens too
could rip and chew
and be refreshed

On this cold flesh
rodents to gnaw on bones
that lie on colored stones

All the liquid residue
in a silent offering
would make early spring
flower all anew
while sun and rain
in still quiet refrain
would let nature know
where once were my remains
tall trees will grow

1-20-1996

PORTALS

I stood within a dream
before a house a door
one I thought I saw before
but when I had entered in
I saw but many doors within
doors that I had entered in before
or so it seemed within another dream

2-23-1996

STAR FIRE

The slow gentle fire
of life consumes
this skin bag
of flesh and bones

What time will leave
behind will feed
worms and nematodes
until life's fire will
consume even those

Within life's burning
changing cycles
this bag of bones
and the nematodes
shall change to stones

Yet even these stone
shall be cast afar
to become a far
flung shinning star

3-28-1996

WHENEVER

I say it now
I say it once again
in as many ways as I can
how can I make
you understand
as to the importance
as to now or when
should I see you
once again

For as many days
in as many ways
are allowed to each
by circumstance
or where we
find ourselves along
the way

Should the situation
make allowance
I would prefer
if not a constant
a long term affection
for the many
many days ahead
of now

4-23-1996

WHATEVER DON'T

You may tell me I may
but don't tell me I will
and never that I must
certainly that will make
my hackles rise up

I've a mind of my own
I think that you jest
if you think you can guess
what goes on in this head
when at times I must wonder
what thoughts are my own

Surely I'll never pretend
that I have knowledge
of what goes on in your head
so whatever my thoughts
don't make them your own

5-6-1996

CHOICE

A poet taught me this
the mind can make you ill
or the mind can give you bliss
for you it is which ever one you will

5-9-1996

NEVER ALONE

No matter where I am
I am at home
in London or Siam
single but never once alone

5-9-1996

INTEGRATION

When I commingle with the trees
and breath the gentle mountain breeze
it soothes both mind and body to ease
allowing heart to become the scene it sees

5-9-1996

SELVES

The inner and the outer selves
set upon two shelves
it is easy to perceive
with no desire to deceive
either one of either self
that both are of the same self pelt

One the image of long yesterday
the one mirrored on this day
both at times hard to reconcile
while the inner knows many miles
it recalls the many memories
of all my many yesterdays
holding to good memories
for all those years

The outer self that ancient gent
has many years perhaps yet
there is no dispute but less
numbered years shorter ever more
less than those that went before
the fires within burn brightly
within the mind if not the flesh
and the current outer self
finds self in so many ways

6-5-1996

VERY STILL

Where do lost bodies lie
deep in the dark dark depths
of the largest deepest wells

In the thickest thicket of briers
along the loneliest of lonely roads
beneath abandoned abodes

Behind no trespassing signs
down in the dark cool pools
deepest of holes to gather souls

Beneath flowering garden plots
beneath those empty lots
lost bodies lie most everywhere

They lie there very very still

7-11-1996

MIRACLE

A very pregnant pope
that would be a miracle
for which all should hope
to help the very many
to become so many few

A sex change for this man
plus sex hormones too
then a pregnancy or two
just to change his view
a woman for a pope is due

7-15-1996

WHAT I BE

Without pretense or sham
to be what it is I am
to teach what it is I believe
with no desire to deceive
no need to hold in memory
my acts or tales of yesterday
but free to tell what I perceive
as I comprehend it day by day

7-18-1996

NATURE'S WHIM

It isn't the lord
that makes it rain
and all your praying
will bring no change

Will not change blue skies
while all about you dies
there is nothing at all
that you can do
when you farm dry land

If you pray too long
for the long desired rain
you eventually may get
a most horrific hurricane
but it will not be a god
who will do you in
but merely nature's whim

7-20-1996

UNASYLUMED

The confused
the bewildered
the ill
set free to wander
hinder and yon
destitute beggars

Shrubs as shelters
the underside
of freeways and bridges
abandoned shells

In overgrowth any where
patrols are unlikely
in the darkness of night
to roust one from sleep

Set free
to become beggars
the unwanted
the forgotten
homeless desperate

Knowing but endless
days of need
without hope

That tomorrow
may end the endless
need of all yesterdays
rape violence death
or otherwise lies
waiting in the darkness

7-21-1996

ONLY BECAUSE

Why them not me
why not some one else
why now or ever

For one good time
is as obvious
as any other time
and any place to die
is a good or as bad
as any other place

Just because they
they were there then
and in no other place
for you query
needs no other reply
nature provides none
accept voids exist

7-22-1996

FOR YOU

The least of my desires
is that I should offend
or should compromise
either foe or friend

If you found me
less friendly than presumed
you perhaps gave no sign
you wished me otherwise

It takes but a smile
to release the friendliness
the loving gentleness
I hold for you inside

8-11-1996

BITTER END

Wife I said
if we are to love
we must be friends

No she said
if we must wait
until we become friends
we will never love

Our love my wife
has found it's end

8-11-1996

A JOHN

When solicitations are made
if John were arrested
instead of Jane
perhaps then it would be John
who might get paid

1996

WAR

When young men are generals
and honored men of state
send older men to their fate
on battle fields of war
to kill those that young men hate
then the old would war no more

1996

MYSTERY

Once I met a man
who dyed both ears
both front and back
I did not ask him why
he did not dye them black
or why he dyed them white
nor did I ask him why
he did not dye them gray

1996

BLESSED

Blessed are those who
go peacefully and painlessly
from this dim light
into the darkest dark of night

Death has embraced them
into the eternal cycle of life
where all join ultimately
within that cosmic unity

Now only in memory
as the brightest of stars
on a moonless night
they shine forever bright

12-24-1996

SOLID GROUND

If life is an illusion
I reject that illusion
for the solidity I find
should I accidentally fall
I prefer to find solid ground
than find nothing there at all

1997

HELL DRIVERS

When we are young
we are hell drivers
cock sure and ready
to ramrod our way
over and through life
come hell or high water

1997

MASTODONS

Stars do not care
if we survive
nor do stars care
our small ruin
those long gone
shall no more
return to see
the breath of earth

Neither great nor small
once gone gone forever
without return
and so shall we
and the mighty disappear
to become the very
dust of earth

1997

OF EARTH

You ask
where shall I go
what road
what way
what god

Go where you will
take what road
in any way
that you may

There are no gods
to guide you
you have left
all gods behind

They were of you
born of fear
born of desperation
conceived in darkness
of the unknown

You are of earth
gods of heaven
will not find you

You are earth bound
soul and flesh
even in death
earth will bind you

You are of earth
you are of mud and air
you are a slow fire
forever returning
into the multitude

5-30-1997

LOST AND FOUND

Should I loose
my most precious
may who finds it
finds it more precious
than I ever found it

6-26-1997

BALLS

Don't kill flies
with canon balls
especially if flies
lie sleeping
on your balls

8-14-1997

OOPS

One driver passed another by
the other took offense
he pulled his forty five
shot the passing driver dead
later to discover
he'd shot his father in the head

8-15-1997

INTRUDER

I would intrude
much more often
but I hesitate
to intrude
upon someone's
seeming solitude

I would reach out
but I hesitate
most passers by
eyes downcast
or averted aside
unsmiling faces
but if they smile

8-16-1997

HAPPINESS

Happiness is
your kiss
your touch
a friend's
companionship
a pleasant
fragrance
a field
of flowers
you being there
early
and I on
time
silence
sunshine
the doctor saying
I find nothing
wrong
a pleasant
dream
finding you
sleeping by me
a smile

Happiness is
being involved
the completion
of a neglected
project
a labor of love
creating
a combination
of words
a design
twisted
to my own
unique
form of esthetics

A warm or heated
but congenial
conversation
with a friend
or a stranger
a kindred soul

Happiness is
shared interests
curiosity fulfilled
discovering one
new fact

The recognition
of a mushroom
or a flower
never seen before

Finding such
treasures
a colored rock
a crystal
the sound of water
coming suddenly
upon a forest
brook rippling
cold sparkling
over gravels
and cobbles
listening
to the caress
of strong breezes
through the trees

9-5-1997

WITH ME STILL

No loss love lamented
only memory augmented
down the many years
like fine ambrosian
sun drenched wines
flow down golden fine
long remembered

Touched now and then
again sweet recall
as a gentle fond touch
comes back like the sudden
rays of sunshine through
the dark cold clouds

Or a storm struck winter's
windy day or the touch
of warmth of early spring
your loveliness has filled
the fullness of my heart
your love is with me still

10-27-1997

WHY LOVE THE SPARROW

The sparrow is of life
as I am of life
that which created the sparrow
also created me
from the same beginning
for the same ending
when all sparrows fall
there may be no one at all

1-1-1998

UNIMAGINED

The most unimagined
can be imagined
the unimagined exists
has yet to be imagined

1-2-1998

LOVES

Three loves had I
each of a differing skein
in woof and weft

Then in between
some short lived loves
that came and went
as most loves go

For three I swore
until death we part
and as love will
love sometimes fades

Then the fading dies
so each by each
my loves and I
we grew apart

1-2-1998

AS ONE

I affirm life
I am of oneness
among the multitude
as countless as the stars

The multitude
mingles within me
as I shall mingle
with all the multitudes
that lie before me

I shall be there
unknowing and unknown
among the darkness
and the vastness
of time and space

I fear not the aloneness
for I and the multitude
shall forever be as one

1-17-1998

NAUTILUS

A chambered nautilus
I would be
within each chamber
another me
so each and every day
in an other chamber
I could be
another me in every way

2-13-1998

THIS IS IT

This is it
a not so solid earth
skies that change
water that flows
the air you breath
and time from infancy
until infirmity
perhaps a century

With fears of dreams
or highs or lows
the many lovers
the illusions
and the delusions

The joy and pain
the loss and gain
what you touch
and what you feel
what you see
and what you hear
within the now

What is near
no mystery here
no gods no demons
no guiding stars
only friend or foes

What of earth
you learn or get to know
what you love
what you appreciate
makes this great
love it or leave it
this is it

2-14-1998

THOSE WHO KISS DOGS

There are few who would end
kissing dogs at either end
your dog may be your friend
it's no reason to kiss the end
that recently cleanest the other end

2-20-1998

FROST

Frost ferns form
wonder winter forests
upon window panes

2-21-1998

RIVER

Upon a ridge brow
light wells up
where a river glows
flows between
tall gray granite walls
there I conjure
a broad delta goes
before the river
flows brown
into a deep
green sea

2-22-1998

POLYPOROUS SULPHUREUS

Like Abraham's fiery bush
a forest snag all aflame
all in autumn color
red-orange and yellow
bright within the sun

Shelf on many selves
one upon many others
a feast to eye and tongue
cut it yields a yellow blood
bitter by night
yet mildly sweet by day

3-18-1998

NO WARRANTEES

Choose wisely those
who you would please
love has no warrantees
no yearly guarantees

You may love those whom
you please
and please those whom
you love

3-20-1998

PUZZLER

Once there were none
and none were we
then there were many
the many became one

The time will become
when people shall see
when the one and the many
shall again become none

3-23-1998

ASTROLOGY

You ask my sign
and I say to you
the sound of your voice
your gentle touch
our conjunction
has moved me more
than all the stars
throughout the heavens

Beside you now
your love obscures
the constellations
the universe fades
in the magnetic
field of your love
that obscures the light
of all the stars

3-23-1998

BE STILL CHILD

The walls hear
and the shadows
listen to your whispers
your innuendoes

The rooms are shocked
they watch you
little they have
to occupy their time

Your fantasies disturb
their sensibilities
their sense of offense
their orientation
of perceived acceptance
the need to control
their need to mold

Speak softly
think silently
be still my child
life need not be fair

5-6-1998

THIEF

Bless this warped twisted body
war has stolen my limbs
give me arms to touch you
let me have legs to walk
give me sight to see you
repair my injured mind
in my forlornness
forever I beseech
give us peace

5-6-1998

CONSTANCY

Nothing
nothing stands alone
outside of time
even the Illusions
are forever changing

We yearn to find
the elusive elements
even when the galaxies
and the universe
knows but constant
change

5-16-1998

SHE

Her eyes were of amber
her lips were ruby red
her breast of alabaster
her heart of molten gold

I sought her eyes of amber
kissed her lips of ruby red
touched breasts of alabaster
never found her heart of gold

8-8-1998

ALWAYS

Mysteries shall abound
some never to be found
for each mystery acquired
exposes more to be inquired
it is no reason to be despaired
only more mysteries to be aired

8-12-1998

HANG CHRIST

Let's hang Christ
on the christmas tree
he has been eulogized
popularized and capitalized
should he return
he would not recognize
himself with his own eyes

Let's hang Christ
on the christmas tree
pretend he really died
and all the stories
we have been told
are fabricated lies
would we ever dare
and would he even care

8-13-1998

SPIDERS

Why do spiders
have to get right up
in your face

Why cant they stay
in their place
like behind walls
and never inside

I just dread
when I find them in bed
I much more prefer them
down on the floor

There they are much
easier to ignore
but I really would prefer
they live out of doors

9-9-1998

OCTAVIA PAZ

You
speak of words
written words
spoken words
hard words
soft words

The shape
of them as carved
hard on paper
as pictographs
in dark caves

Stalactites
to pierce our awareness
words that dissolve
flow as in great rivers
a great flood streaming
through consciousness

In the depth
of deepest dreams
did not lack of words
ever find you

Was the stream
ever dammed up
did not silence
the sereneness
of silence descend
envelope embrace you
as clear cold water
into great stillness
the essence of being

10-5-1998

WHO

Who who who
is the owl hooting to
the now stilled mole
the skittering mouse
or the fluttering chick
deep in the dewed ferns

Who will the owl choose
on it's feathered silence
like a hushed breeze
across misty meadow
from the dark tree
who will the owl choose
who who who

10-20-1998

COGNITION

Once knowing
never is the question
one of necessity
as to the object
only of its function
its purpose to serve
to the satisfaction
of the perceived needs
cognition known

11-14-1998

WOULDN'T YOU

If I were very
very hungry
I would cut
little animals in two
for a perfect stew
wouldn't you

If you were
very very hungry
wouldn't you
cut cute little
animals up for stew

If you could catch
little animals too
I think you would
wouldn't you

If you were very
very hungry
have little animals
for stew

11-15-1998

CALLIGRAPHY OF BIRDS

Sinuously
curvilinearly
unidirectional
flowing as singularly
yet multitudinously
against steel skies
over gray waters

What inner flame
allows the inner change
to know which will follow
or which shall lead
as in rapture freed

11-17-1998

EMBRACED

Your eyes engulf me
I drown in your passion
I flow endlessly
into the warmth of you
wishing forever to be found
in your embrace

12-1-1998

MATTER

If in all of space
there was no matter
would space exist

If all of space were matter
would space exist

If all of space did not exist
I doubt it would much matter

12-7-1998

AMISS

There was a young miss
who experienced great bliss
until she found this
one item amiss
her fellow she found was a miss

12-14-1998

UP OR DOWN

Oh! human kind
disturbed to find
he has left it up
and she has left it down

Has it not occurred to mind
that she could leave it up
and he could leave it down
in order that they might find
a lasting peace of mind

The great debate
as of this date
is as to whether
the toilet paper
should go over
or under the roller

12-23-1998

POINT OF VIEW

Though your heart may be of stone
it gives me pleasure to tickle
your funny bone

It would please me just as well
when you read my poems
to see your anger swell

It disturbs me not the least
if you see within me the beast

As long as my poems excite you
and exposes you
to a different point of view

12-23-1998

TERROR-TORIAL DOGS

Fear not
I will not bite
rarely bark
and seldom growl
but I get most disgruntled
with other people
who unleash their dogs
upon the forest trails
or in public parks

They say
"It is a friendly dog
it only loves to bark
it really would not bite"
as the dog it strains the leash
smiles to show it's teeth

Most of all I'm mad
and terribly sad
when a child is bit
and seriously mauled
by such a friendly beast
and the dog owner cries
to think the dog may die

12-26-1998

BIRDS DO

Look for birds
but do take care
when they rise up into the air
and fly just over head
if you look up beware
there may be more than feathers
in the air
should you walk
from where they flew
on the grass you will find
more than dew

3-7-1999

CONGREGATION

All the gods
all the angels of heaven
plus all the demons of hell
and all the imaginary beings
ever conceived by human kind
would readily sit on less
than a tenth of the head of a pin

5-23-1999

NEEDLESS

Such needless sorrow
they say it was god's will
that six should die
and one should live

God did not make
the driver dead drunk
or choose who should live

It was not god's hand
upon the wheel
liquor dealt the deal

7-11-1999

TIME TO GO

Death is neither friend nor foe
those who grieve
grieve of self sorrow

If faith were adequate
friends would celebrate
the deceased did elevate
into a celestial state
or perhaps just as well
with friends in hell

Those whose faith in nature dwell
know not of heaven or of hell
know death is neither friend nor foe
but only a timely time to go

7-25-1999

MEDITATIONS

I can do nothing
and be satisfied
most content
without thought
or desire
a gift

Other times
I allow thought
to flow effortlessly
as water flowing
down stream

I see within
neither the living
nor the dead
but the imagined
as in dreams

8-3-1999

WONDROUS WORLD

My eyes are downcast
and on the ground
not that I am humble
but due to all the mushrooms
and pretty stones I've found

Some times I look up
into clear or cloudy skies
to watch feathered creatures
flying low or high

As often I look between
the highs and lows
at grass or lower trees
seeking small furry creatures
that share their wondrous
world with me

8-4-1999

WORRY?

I have no need to worry
as yet I Iive
when I am dead
I shall have no need to worry

1-16-2000

LEMMINGS

Millions of lemmings
run after other lemmings
into the sea

So people follow others
down the centuries
to ask others

What they should believe
most never ask why
few ever will

1-16-2000

ERECTILE DISFUNCTION

Sex may be in the head
but when the penis doesn't rise
you will find it no where else instead
regardless of sages saying otherwise

1-17-2000

RELIQUARY

Bones are bones
regardless to whom
they once were owned
whether secular or saint
they are inanimate
no power of their own
no spirit with them dwell
to make the ill be well

The only miracle that exists
in the contortions and twists
within the human devious mind
seeking convenience to be blind
rather than using the brain
that nature so generously gave

4-28-2000

CYCLES

When the flowers have gone
and the leaves have fallen
they have not truly gone
they are again becoming

As the birds that die
and the dead frogs in ponds
as the dead never found

After winter's long sleep
they will rise as spring flowers
as new bright green leaves
even as feathered birds that fly

In death all life
does not truly die

5-11-2000

SINGLE

No expectations
but your own
lay back in your chair
there is no one there
no one to say

This very day
I have a hundred
chores for you to do
you have promised
you would do

But all alone
you can ignore what's due
let only thirst and hunger
move you from the comfort
of your favorite chair

The chair that can
warm massage vibrate
even entertain you
with music and the news
when there is nothing
you wish to do

With no expectations
but your own
when you are single
and alone

5-14-2000

WHERE DWELL

I would most be
between land and sea
high enough to look
to the far horizon
close enough to walk
a rock and sandy shore
to explore and garner there
what the sea would share

Yet high above the sea
upon solid craggy rocks
yet low enough below
the dark green hills
where I might run happy rills
on sun spangled trails
collecting edibles there
to complement the ocean's fare

5-18-2000

NIRVANA

Light up
said the Buddha
inhale ganja
breath deeply
allow thoughts
the inner voice
like butterflies
to fly away

Into nothingness
and non being
and all being
into one and all

Seeing but not seeing
hearing but not hearing
be wound within
the web of existence
endlessly be now

6-8-2000

BECOME A RAVEN

Raven raven dark as night
in the deepest forest dwell
would your secrets to me tell
if I could cast a wondrous spell
that your tongue could take delight
to tell me all the tales you might

Come sit upon my shoulder let me hear
speak the words within my ear
but better still raven if I may
set within your mind to stay
to become a raven just one day

6-15-2000

STARTLED

A dappled camouflaged fawn
erupted suddenly from under foot
dashing away in fright

Two does stopped stood still
nostrils scenting the air
aware of human presence
haunches quivering
alert anticipating flight
gone silently

High Sierra above timber
the cool dry stilled morning
burst with the harsh rattle
and hiss of a rattle snake
my heart pounding
adrenaline screaming

Silently a tall silvery snag
behind me unseen
falls explosively
across bare granite
only seconds away

7-4-2000

AUTUMN TREASURES

Autumn rains
still warm days
cool nights
entices them out
from the soil
along wooded trails
under Oregon grape
under salal and Douglas fir
out of stumps and snags
reaching out
of thick green moss

Edibles non edibles
fruit delectable
eye mind bending
fit for god makers
for mice and men
for slugs and snails

Whites innocent as death
bear's heads
lion's manes
devil's trumpets
yellow funnels
some blue black
red dotted ones just for you
multicolored shelves
for elves and toads
some truly
table treasures

7-5-2000

ILLUSION OF SOUL

You are your
own essence
only existence
contributes
to the ultimate
meaning and purpose
which is yours
to choose

8-8-2000

ECHO

Shout against the echoing wall
and you will hear the echoing call
the echoing call will bounce wall to wall
but never reveals any secrets at all

11-2--2000

MANIC

I fly like the breeze
I run into trees
I walk around
ten feet of the ground

I walk on the air
when falling down stairs
while walking someplace
I suddenly awake

I have such wonderful dreams
life is so glorious it seems
until I find myself down
back on hard solid ground

But then I can not deny
it is so great to be high
to exist or to fly
under a pink or blue sky

11-14-2000

BEFORE AND AFTER

Men often masturbate before hand
so they may longer sustain
women should they not attain
do so afterward by hand

11-14-2000

THINK OF THIS

Between now and then
before we are forever when
we realize what we ken

So it should be no surprise
should we open up our eyes
to find we were not wise

But just you think of this
being wise you might have missed
the great pleasures of ignorant bliss

11-15-2000

BY THE SEA

I love to sit at the waters side
in the golden light of eventide
watching passing lovers strolling slow
bathed within the sunset's glow

Rarely do they ever notice me
the white haired old man by the sea
but now and then a couple turns to smile
I warp it about me to warm my heart awhile

11-16-2000

KISS THE WIND

Kiss the wind that goes
before the rain the sleet the snows
like good friends that come and go
some blow fierce some go slow

Kiss the wind that sighs
under bright and cloudy skies
like good friends who love you so
how tomorrow they will go

Kiss the wind that blows today
the wind that blows every way
as good friends whose hearts sway
here yesterday now gone today

11-19-2000

A HOLE WITHIN

Man found within himself a hole
he made for this vacancy a soul
then found he a vaster vacancy
so he created a theocracy

2-9-2001

SIGNS

I could better understand the blind
who see visions in their minds
than those who see virgins behind
the back of highway signs

2-10-2001

NOT IN VAIN

I shall not have lived in vain
if I can save another's pain
or if I find a way to show
another knowledge that I know

2-14-2001

WELL SERVED

If I have entranced some
with nature's wondrous spell
I will consider that I have done
them favors that served them well

2-14-2001

A LION'S LAIR

If you fall into a lion's lair
don't you ever ever despair
for lions accept any one there

However don't shout or run about
if you run out of the lion's lair
outside the lair he will eat you there

So remember always beware
never fall into a lion's lair

But should you and wish to escape
be patient just you wait
until the lion is no longer there

3-11-2001

A WALL

I did not wish
to build a wall
I did not will
to build a wall
at all

It was silence
that built the wall
her and my silence
shattered not the wall
at all

She stood within
the hall against the silence
and the wall
turned out the door
without a word
at all

3-20-2001

TREES

Once this world was a world of trees
shall we ever see a world that is bare
because there are so few that care
is this the world that the world foresees
a dead and barren world for lack of trees

3-20-2001

HUMBLE DAISIES

English daisies are white stars
against a green heaven of grass
small and humble flowers

First sight harbingers of spring
so delightful to the mind's eye

Imagine endless green meadows
spangled multitudes of daisies
a milky way upon green green grass

4-4-2001

FACTS

Facts are facts
and that is true
but what is truth
to one another's lie
may or may not be
based upon facts
beliefs neither be
either truth or fact
and that is that

4-5-2001

WHEN YOUNG

Three wives had I
or they had me
when life was young
and love easier to come by

But by and by each
one went their way
and so did I

Between each love
we took our time
our pleasures not denied

12-15-2001

ONLY YOU

The devil gets blamed
for what humans do
just tell the devil
what he can do

You know damn well
there ain't no devil
and there ain't no hell
one to blame is you

12-22-2001

WHY A WAILING WALL

Should I wish to wail
I can wail to an open sky
can curse this very ground
I can damn all of earth

I do not need a wall of stone
for what myself I can atone
for if atonement means forgiveness
I can learn self forgiveness
without a wailing wall of stone

1-6-2002

CROSS OF PAIN

Whose cross I wear
I do not much care
it is the pain I bear
a beast fangs bared
my very bones it's lair
my flesh it's only fare

1-11-2002

ARISE

I can reach up up
into the night sky
catch falling stars
cradle the moon
become the night

I can become one
I can become all
when the sun rises
then I am the sunshine
one with the rainbow
the light song of day

1-12-2002

CREATIONISM

We created all the gods
that never were
we shall create all the gods
that will ever be

1-13-2002

BE AN EAGLE

If I could an eagle be
to fly up into the light
broader than all the sea

Stretch wings upon the air
flying tensioned feathers there
gliding skyward screeching glee

Oh! to be an eagle free
to be master of the sky
to be an eagle yes to fly

2-12-2002

DREAMERS

Flights of fancy
fancy free
dreams to see
what may
or never be

Dreams of night
and dreams of day
are neither stone
nor made of clay

If nature dreams
of things to be
creatures that never
see dreamers
they can be

3-5-2002

INSEPARABLE

I am no particular one
yet one with everyone
inseparable from the first
and never to be last

With all those of the past
with all those to ever be
for unknowing and forever
we shall be bound together
in the continual chain
of remorseless endless change

5-1-2002

BONES ARE BONES

known and unknown

the dead are ever dead
life then long ago fled

known or unknown
bones are bones

bones are of earth
they are most inert

known and unknown

bones become dust
bones become us

bones are bones
known and unknown

bones shall not arise
bones bare no surprise

7-15-2002

AGLOW

My being is
a loving praise
upon all on which
I daily gaze

The light
by which I see
the very air
by which I hear
'tis all of life
which I hold dear

All of nature
land of trees
land of hills
where cool waters
rushing flows
there is where
my spirit grows
my inner light
becomes aglow

7-16-2002

GODS

gods beyond numbers
gods to fear gods to love
 gods below gods above
gods of many members

 gods of one gods of three
gods for every kind of tree
gods for all mushrooms
gods for all empty wombs

gods for all soft erections
gods for all fertile wombs
gods for varied selections
gods of select delectations

7-17-2002

THREE YOUNG GIRLS

four to six
walked through my gate
as I sat on the porch step

They were from across the street
of the block on which I live
I knew the oldest one
who often greeted me by name

I am the oldest man
seen on our block
white hair and beard
I often carry a staff
a small back pack
and wear a hiker's hat

Different from local fathers
retired I don't work
I am a picker of mushrooms
godless and undoubtedly
strange and eccentric
without wife or children

The three girls line up
before me at a safe distance
then one said "I am six
I am in kinder garden"
she continued "who are you
are you a man or a clam
what are you after?

As you can see
I am an old man

The youngest and the shortest
said "I can dance"
so she twirled about
and did a little jig

The third one was shy
and she didn't say a word

Suddenly the concerned mother
of the littlest one appeared
all frowns stern and defiant

Without a greeting to me
or a hello or a goodbye
without saying piss on you
you dirty old man
she rushed all three away
across the street

Where I am certain
she admonished them
about the dangers
of befriending any old
white haired man
who could be a predator
of young girls

9-15-2002

NOTHING SACRED

nothing above
nothing below
nothing beyond
nothing a miracle
nothing unquestionable
nothing but nature
and nothing more

9-27-2002

HOAR FROST

hair like
delicate
fragile
spun by
fine pores

dissipates
vanishes
by a warm
breath
or the touch
of the tongue

10-12-2002

TRUST

An attractive
blond male child
perhaps age three
striding before his mother
arms akimbo
a beatific smile

He waved at me
a stranger
as an old friend

His mother said
"there is an aspect
of you which he
finds to his liking"

My entire day
became brightened

10-18-2002

REALLY

I rarely
attend parties
or where there
are many people
I just tend
to avoid large groups
or any crowd

Once I attended
a social dinner affair
in a strange city

A stranger
a gentleman after
staring at me
for some time
walked up to me
and said
"you are Dr. William's"

He insisted
"Surely you are he"
sorry
he may resemble me
but I truly am not he

All that evening
he kept looking askance
toward me
as though I didn't
know who I am

11-2 2002

WHICH EVER

Three wives
and your out
three crimes
and your in

More times single
than married
Glad the first time
was not the last

Your world will
never be the same again

Would you have it
any other way
Which ever way
accept it or change it

Where ever you are
be there

None of the above
may concern you
Don't laugh you
may have a stitch in time

11-5-2002

THE TEST

Once I went
to a wise man
so he might tell me
what I might be

For many weeks
this wise man
gave me tests
upon tests

In the end
the wise man said
"you can do anything
that you wish to be"

But he didn't know
and I still don't know
what ever it was
that I wanted to be

So I turned away
still not knowing you see
so I became whatever
it is that others see in me

12-9-2002

APPLES

An apple to day
sells for a much
as once a bushel
or as two pecks

1-4-2003

CHIPMUNKS

Chipmunks love a game
running in the on coming lane
then suddenly changing lanes
to play the game of chicken
until over driven

1-10-2003

COVER ME

Haul my ashes
cash me in
roll me out
lower me in
cover me over
let the grass grow
with flowers and clover

1-15-2003

OH SEA

Beat beat oh sea
on the night's dark shore
beat as the hearts beat
of lovers by the shore

1-15-2003

ENDLESS

I am the beginning
and the ending of self
a living and endless cycle

I have arisen
from the primordial
from an endless chain
into the infinite future

Wherever life arises
and eventually dies
that other life may be
forever becoming
forever endless
cycle unto cycle

1-18-2003

DEATH'S DOOR

When you step
through death's door
you will find
much less than more
of heaven or hell

In death
should I find
either heaven or hell

I shall be mostly
shocked & amazed
but accept a done deal
I don't expect

Rationality and reason
leads me to no
such expectation

1-21-2003

EELS

I don't knew how you feel
about the feel of eels
but when it comes to meals
I favor mine as roasted eels

2-10-2003

DEPENDENCE

Upon miracles
the saints the fates
that good luck and bad
lurks around the corner

Angels sit upon
the right shoulder
that last minute
redemption shall save
us from the imaginary
fires of hell

Or transport us
into the non existent
gates of heaven

Those who so believe
we depend upon them
to save the world

2-10-2003

VERY STILL

Where do bodies lie?
deep in the dark depths
of the largest deepest wells
in the thickest thicket of briers

Along the loneliest of lonely roads
beneath those abandoned abodes
behind no trespassing signs
down into the dark cool waters

Deepest of holes to gather souls
beneath flowering garden plots
beneath those many empty lots
lost souls lie most everywhere
and they lie there very very still

5-7-2003

TIMELESS

Time to some
is as ephemeral
as their span of attention
and ease of distraction
by both the external
and the internal

So an appointed time
is as flexible as dreams
or the vivid imagination
and a place of connection
a mere vagueness in space

Speed down the highway
lost to sound signs time
and missing invisible exits
the place of appointment
by only a near mile
time by a full hour

Contacts gone unseen
a wonderment
as to why no one is there

6-13-2003

THE GAME

Place faith that truth
in nature dwells
nature does not lie
it holds no motive
it does not care
whether you live
or whether you die

You are entirely one
with all of nature
as nature made you
and what you will be
integral with all of nature

You can do of it
what you will
it can nurture
or it can kill
to break the laws
of nature
can produce disaster
and disorder

6-14-2003

SONG AND DANCE

Egregious Scott John Law
self declared duke of Arkansas

Sold the wealthy of France
a lively song and dance

How the city of New Orleans
then a figment of Scott's devious schemes
would make them all kings and queens

He sold them all a generous share
of wealth of jewels and yellow gold
with statements wondrously bold
sold them what then was never there

He sold each French millionaire
all of Louisiana share by share

When Scott John Law was through
straight away from France he flew

He'd broken the banks of France
without ever a backward glance

Scott John Law I do declare
lived the life of a millionaire
while leaving all of France
only a wishful song and dance

6-15-2003

BY CHOICE

To reason is to be
unreasonable
to seriously question
is unquestionable

Conform to form
speak as others speak
dress as others dress
believe the unbelievable
to be acceptable

You are for them
and with them
or against them

Or you may

Be free by choice
to hold nothing
sacrosanct or holy
to pursue peace
over violence
to seek knowledge
over ignorance
to hold no one
worthy over another
to worship nothing
but life and nature

6-17-2003

BECOME

Some seeking a state of bliss
would consume their own piss
some others if it would drive
their minds adrift inside

If you don't mind
to loose your mind
or go completely blind
to see what lies behind
the unconscious mind

You might be first
to go beyond the universe
to go beyond the beyond
not care where you have gone
never worry around the turn
you may never never return

Would you would you dare
to become entirely aware

7-8-2003

BEWARE

Should you care
for grizzly bears
and think that they
are gentle teddy bears
please be aware

They now and then
love to snack on berries
and now and again
for just a treat
they have a yen for meat

They do not care
what clothes you wear
or how you comb your hair
they prefer you clean and neat
for you to be a special treat

10-8-2003

STINGING NETTLES

On a dark sea
men whipped themselves
with stinging nettles
into awareness
alert to the blowing
of whales

Cold stiff fingers
coiled lines
from stinging nettles
tied to harpoons
and seal gut floats
ready for the rising
of whales

While women
in long houses
drank hot broth
of stinging nettles
to brighten dark eyes
to lend sheen
to black tresses
while waiting for men
from the sea
with whales

10-22-2003

NETTLED

Touch the nettle
if you will

You may find
it's done you ill

When you feel
the nettle's sting

It's fibers are
for making string

It's leaves boiled
a healthy broth

The leafy residue
a tasty stew

10-22-2003

TOUCH

Touch the language
of ancient love
before words became

Hands and fingers
are little animals
walking lovingly
the length of you

Without words
their touch speak
only of affection

Speak to me of love
only in tongues
whispering silently

The touch of lips
the touch of tongue
the touch of skin to skin
the touch of love
without within

10-23-2003

THE CHILDREN

When will the children
of all my children
know a world that's sane

Only when our world
allows a world of change
to build a world that's sane

When all the children
know they are the children
of the universe and of earth

When the children's children
they all solemnly aver
earth's care forever

When children know war
only as an impossibility
and peace a constant reality

In the meantime
during the killing time
millions shall perish

They will be children
of my children
and your children

1-31-2004

IMAGINARY

Imaginary time
is like an imaginary line
or an imaginary anything
of any size
may be large or small
or not exist at all
an imaginary man
can do with it what he can

Imagine the imaginary man
imagining time had not began

1-31-2004

TIME

Haven't we all
have all the time
ahead of us
time to waste
time to share

Time to put off
until tomorrow
or the next day
old or young
we have all of life
ahead of us

Time behind us
for memories

5-21-2004

AUTUMNAL

Summer days slip away
temperatures drop

Southwest dark clouds
portend wind and rain

Cold damp air
stiffens these old bones

Yet I look forward
to Indian summer

Cool nights courting frost
the painted leaves

Cottonwoods pillars of gold
vine maples crimson

Leaves falling like
colored rain

5-22-2004

PATER NOSTER

For our father
who are not in heaven
never there in heaven
where you never were
and we shall remain
forever upon earth
to enjoy it's wonders
forever and forever
as long as we shall live

Ours is the wonder of life
and the mystery of death

Our is the wonder of the seas
the greatness of green forest
the intimacy of friends
and all the challenges
of the wondrous unknown
to be sought and discovered
fulfilling the wonder of life
and death forever upon earth

5-23-2004

HUMANKIND

is nature's own
known and unknown
nothing less nothing more
nothing sub-natural
nothing super natural

Only nature for us
to understand
to deduce the seen
and the unseen

We are of nature made
and unmade

Our small world
shall be maintained
or not maintained

Whatever way
ultimately nature
will have it's own way

9-8-2004

DEATH

Death doesn't come to soon
it has no appointed time
it is the end point of life
by illness or by strife
by no fault of one's own
by catastrophic events
by raging storm
by trees that fall

As the meadow lark
in mid song ends
it's heart no longer beats
it falls insensate
from it's lofty perch
to join the mold of earth

Some go by intention
some before their birth
some live to be elders
but sooner or later
all return to earth

9-23-2004

PEDESTRIANS

Yes my bright
loving grand daughter
you ask your grand father

What religion is it
our family believes

None my child
for as long
as memory serves me
and my father before me
we have always been
pedestrians

You inquire as to what church
we are members

We have never been
members of any church
only and always
we were pedestrians

When troubled
or needed solace
we walked our troubles away

Once resolved we always
returned to those we loved

9-17-2004

COINS

Coins are hardly
worth their metal
not worth melting

Worth less each year
hardly worth their weight
to carry

They hardly carry
their own weight

9-28-2004

CHICORY

The robin egg blue
blossoms of chicory
along the highways
are bitter friends
that have wandered
across the nation
into our coffee cups

9-28-2004

THE END

I'm one of those strangers
that will talk to most anyone
particularly if they are willing
to consider a few thoughts
other than their own

On a moments notice
I am willing to exchange
both the possible and impossible
which does not mean
I will accept either possibility

I've been exposed to more
of religion than most would desire
my father was a frustrated priest
who had children instead

Now the above is just
a long way to a short story
about a fellow who knocked
on my door to tell me
he had a message for me

He began by telling me
that the end of the world
was near at hand which was news
for the world has been here
around a few billion years

Yes he said He is already here
and awaits the proper time
so after a number of visits
and neither of us changed minds

I inquired if he had children
four and another on the way
so when this fellow doesn't show
how will you explain to them

He made no reply
and never returned
Nor did that other fellow show
and that was forty years ago

9-29-2004

ANOTHER STRANGER

As I have said I will converse
with the best and the worst
and meet the most interesting
people that way

Well one day while alone
there is a knock on the door
when I answer I see
this man all dressed in black

He tells me that he
is interested in my soul
I tell him no deal if he
is interested in a purchase

Oh! no he then says
Im only interested in
the salvation of your soul
no deal I tell him

By chance there is a black cat
run over flat on the street
so I point to that cat
saying I am no more concerned
with my soul than that
of the cat

9-29-2004

THE SLUG

Slick slippery
very slimy
slides silently
leaving a silver
trail of slime
as it dines
on leaves and vines

9-29-2004

FIRE DRAGON

Once I entered
the burning embers
the flaming maw
of a great dragon
to become one
with a multihued
universe of endless
changing space

10-4-2004

SO OBVIOUS

The sun never rises
nor does the sun set
it is the world that twirls
as it circles the sun
it is the morning that rises
and evening that sets

10-05-2004

NO SIN

No reason to resent
being a dissident
being eccentric

Or at odds with
the great majority
of society

It is no sin to desire
a paradise upon earth
instead of hell

10-12-2004

LUCK

Non such
good or bad
synchronicity
on the basis
of probability

The turn of a card
is neither luck
or bad luck
except a stacked deck
is a calculated credit
to house or dealer

10-12-2004

INTUITION

We only observe a tenth
of what it is we see
yet the unknown ninety
may tell us more of the world
and the universe
currently knowing no other

Should we but intuit patterns
not consciously observed
for in all things seen
or unseen there is a logic
a cause in all of nature

Regardless of all the mysterious
the magical and the mythical
explanations some would attribute
to ancient fiction and ramblings
of honored philosophers long dead
and the gods who have joined them

10-13-2004

COMPUTERS AND PEOPLE

Computers are neither
smart nor stupid
most people are not stupid
but rarely analytical
thinking has not been
an element of their concern

It is easier to believe
everything
than to believe nothing
more difficult yet
to choose facts
by which to believe

Computers neither lead
nor to they follow

Information can be chosen
from misinformation
the mythical and mysterious
are more intriguing
than factual truth
but less enlightening

Enlightening strikes
fewer than more
as the state prefers

10-18-2004

EMBRACED

Annette lake
took a young man
last spring

She must have needed
male company
he joined her

He swam out
into the cold water
silently she embraced him

They removed him
last summer
from the dark water

The lake would
have kept him as the
snow along it's shore

12-18-2004

TRIPPING

If you wish to see
such as you
have never seen
or dream where
you have never been

Wake up as dead
and be articulated bones
or in infinite space
to find yourself alone

If you wish to render
yourself a different gender
consort with dragons
gods and demons
throughout the eons

In the forest you can find
of a wondrous kind
that stimulates the brain
setting neurons all aflame

If you wake with lack
of ways to bring you back
just imagine that you see
the imagined as it be
as real as all reality

12-20-2004

SEINER

I can see it still
as though it was yesterday
yet it was so many years ago
standing behind a window
at the Stikine River Inn
in Wrangell Alaska

Looking out over
the pewter colored water
into a bright fog bank
back lit by the morning sun
when a lone seiner
emerged from the fog
on it's way to wherever

12-31-2004

ROUGH GO

Any man who has placed
his hand or cock into
a calf's mouth
knows that calves or cows
do not have velvet tongues

They or tigers for that matter
could lick the skin off a man
or his foreskin could he
boy or man have sufficient
tolerance for painful pleasure

1-6-2005

UNDERSTANDING

You are strange
you talk to animals
as though they
understand you

They do understand
they understand the tone
and volume of my voice

I also speak to trees
and they don't understand
but I do understand

I speak to my body
and it understands

1-5-2005

GOD CREATION

Man decided he needed a god
and his woman decided
not to be left out
that she needed one also
to protect her pots and pans
and the soufflé

She reconsidered and decided
that she needed at least three
so he decided not to be undone
that he might need a dozen

She being a dominant wife
told him to get out there
and create as many gods
as they might ever need

So he took up some clay
and from this clay he created
a multitude of gods
they were not permanent

He was not satisfied
so he made some from wood
made some from bronze

They prayed to them
the crops failed
even the soufflé collapsed
and that year was a bad winter

They even prayed some more
sacrificed two young virgins
and next summer
there was a bad drought

So life just went from bad to worst
so they decided they needed
an imaginary god
perhaps in their own image

She thought god
should be a woman
and he naturally thought
god should be a man

They fought and argued
for many years until they decided
that god should be purely imaginary
neither a he or a she

Then others came along and said
It is not one but one in three
and threw in Mary to make four
to confuse it all the more the saints

People still pray
they don't sacrifice virgins
just the funds of their labor
nature has not changed much

Some winters are still hard
some summers are dry
some live some die
There is little change
in human nature

1-9-2005

CURLEW

In the dusky wood
into the forest silence
the curlew's call
is a haunting call
plaintive and lonely
a warbling
watery call

1-9-2005

NEVER ALONE

No one never need
to be an island
they can choose
to be an island
should they desire

They may should
they wish to be
one in unity
with the universe

To be with all
they must open their eyes
must open their minds
must open themselves

To be receptive
of all of nature and know
they are inseparable
from all of existence

1-12-2005

WORDS OF COLOR

One night I dreamt
that each letter of every word
should be a different tone of color
so each word each poem
would be a rainbow of sound

1-22-2005

THIS WORLD

If this is the best of all
possible worlds
then there is no need
to imagine a better world

1-22-2005

SPACED OUT

Or is it spaced in
one state or
three states in one
united a mindless
state of mind

No goal or perspective
mind running idle
meditative
neither here or there
between whatever
and caring less

The world by passing
unnoticed uncaring
of mind vacancy
timelessness endlessly
a short while

2-3-2005

HERON

From solitary stillness
the great blue heron
harks a course bark
twice for my intrusion
rises in one smooth
leap into flight

A modern feathered
pterodactyl
head stretched forward
on a long thin neck
feet like rudders
far behind
huge gray wings
smoothly pivoting
seemingly generating
effortless flight

2-17-2005

COLOR

There is no color
or human kind
I could not love
or adore

Yet find among
any of them
ones I could
abhor

It's not the color
of their skin
but what lies within
that should matter
to any one else
of any color

Worthy beauty
lies always within
below the color
of one's skin

2-17-2005

I GIVE THANKS

I give thanks
to the many strangers
and friends
who have helped me
when I had needs

Or have shared with me
a meal or time
for a conversation

I thank the many
often strangers
who have shared
house or a bunk house
or those offering me
a ride toward

Whatever my
destination was that day

Who shared jokes
and stories of the road
police sergeants
who allowed a lay over
on cold nights
in a warm dry cell

2-17-2005

LOOK BACK

Walking a forest trail
or some mountain path
turn around occasionally
so you may realize
you have passed through
moments of time

Your entire life
is but moments of time

3-5-2005

SISTER

You model of motherhood
have held your brood close
to your generous heart
so each in turn returns
the love and care you shared

3-6-2005

A HOLE AND A ROCK

As though it was yesterday
and it was over sixty years ago
my old man by hand
dug one hell of a hole
forty by forty & eight feet deep
to find a four by five foot
solid granite rock

He insisted he would
remove the rock out of the hole
I suggested he bury the damn rock
stubbornly he insisted otherwise
wise at sixteen I insisted on burial
called him a damned old fool

He decked me with one blow
I more stunned than injured
and having four inches on him
and a greater reach
considered I could take him
but decided he wasn't worth it
so I turned and walked away

Over the years I never inquired how
he removed that granite boulder
nor did he ever inform me
and I never returned to live
in the house build over that hole

3-6-2005

MOTHERS

Some mothers are mean
mine was neurotic mean
she may have had cause
she had a step mother
whose own children
never had a kind word
nor any other relatives
for her that I remember
until at her wake

I made the remark
as to how she looked so well
dead
at twelve I was impressed
by the embalmer's skills

Mother was always quick
with a willow switch
or our father's razor strap
with which she beat us

If we didn't cry out
she would beat us until we did
then when we would
she would beat us
to make us stop crying

If there was no food in the house
she would pretend she was eating
often she would pretend death
so we would show concern
she did this to us when we were young
and later to her grandchildren

3-6-2005

BROTHER

My brother at sixteen
was a bank robber
at twenty he was tried
for attempted murder

At thirty
he was a father
of three sons now
one institutionalized
one a prison guard
another permanently
unemployable
all mistreated as youths
yet loyal

At seventy
diabetic heart failure
wife dead
left leg lost
still cantankerous
but been blessed
with last rights
and holding on

I tell him he now has
a one way ticket to
heaven
he laughs

3-6-2005

DOES SHE OR NOT

She says she loves me
the unspoken question is
do I love her
that is the rub

She has also told me
she has never loved anyone
which am I to believe

Do I love her
have I loved anyone

In the most general way
I love most everyone
but specifically to love
one particular individual

How can I know
when I wonder what love is
does love change
from ravenous rage
of youth to middle age

Now approaching eighty
what is love's reality
the only love it seems
is what I find in dreams

3-23-2005

A JOHN

A john whose last name was Dick
complained his penis was more thin than thick
the ladies were pleased he came more slow than quick
so Dick was seldom short of a trick

4-5-2005

REPEAT

Let your mantra be
as your heart beat
and the mother sea

Let your mantra be
the very breath of life
as the cycles of the tide

Let your mantra be
a vehicle to be free
within infinity

4-9-2005

SPRING FRAGRANCE

Budding cottonwood
with the fragrance of balsam
is the perfume of spring
and the promise of early morels
fiddle heads of bracken
pushing up through last years
dark bronze fronds
and the fresh green
heads of lady ferns

Checking under the moss
laden vine maples
lie the verdant evergreen
leaves of wild ginger
with it's delicate fragile
chocolate brown flower
over shallow rootlets
running wild and tasting
mildly of it's name

It is the perfume of these
which returns to me
enchanting memories
of many decades of spring

4-15-2005

LIBERTY

Is to be free
to worship or not
to believe or not
in gods or myths

It is to be free
to love anyone
of any gender
or persuasion

It is to be free
to do all things
not harmful to others
or the environment

It is to be free
to have security
from violence
and from poverty

4-16-2005

TRUTH & IGNORANCE

Faith or belief
is not the truth
it is second hand
it can only entrap
and another's truth
can not truly
be your own
you must seek truth
for yourself

Ancient truth
may not hold true
to current truth
for it may be based
on far lesser facts
or greater bias
or ignorance

Judge not a truth
on the desire of need
but only on what can be
preferably determined
by verification
confirmed by evidence

Only truth can free you
from ignorance
propaganda and myth

4-18-2005

AN IMMACULATE
CONCEPTION

The conception of gods
can have been but
immaculate conceptions
by the imaginations
of the less than immaculate

4-25-2005

SINCE NEANDERTHALS

The gods do not disturb me
as much as those under the cloak of gods
that have grasped the mantle
of ecclesiastical power to rule
the impoverished of the earth

They have taken upon themselves
the right of exclusive communication
with their imaginary gods
as the only truly enlightened
professing to know the will of gods

4-25-2005

MIMICS

If you yawn they will yawn
if you cry they will cry
if you seek peace
perhaps some will seek
peace with you
if you seek violence
violence will surely find you

4-26-2005

NATURE

Nature is all
from the greatest of all things
to the very least of these
including the known
and the unknown

Nature is inclusive
you may not not be from it
you are a link
in the chain of all existence

Even madness
can not separate you
from the reality of nature

4-27-2005

CANDLE BURNING

Through out the whole long night
I burned the candle end to end
my eyes now find the sun too bright
my back far to stiff to bend
I wonder if my lady friend
now finds the self same plight

4-30-2005

SOME MEN

Some men most men
with the roving eye
can not but make passes
at passing women
as they pass men by

These men most men
will be husbands by and by
with still the roving eye
'til life bids them goodbye

4-30-2005

SWEET CHANGE

In bed within his sumptuous suite
his words within your ear so sweet
he swears he loves you best
of all those he's loved the rest
couldn't hold a candle to his flame
but he wonders if she could arrange
a threesome for future change

5-2-2005

GASEOUS

It isn't great art
but bend over and fart
over very hot coals
watch and behold
a streak or blue flame
if you take proper aim

What comes out of your ass
is an ignitable gas

5-2-2005

VIRGINS

The seventy virgins of paradise
they would be heaven sent
with a heavenly scent
winged or not winged
sexed or not sexed

Males or females
with operable organs
or no organs at all
perhaps neutered
or firmly sutured

To remain virgins forever
waiting for islamist terrorists

Virgins to not wait
for christian terrorists
in paradise

5-2-2005

CHRISTIANS OFF TO WAR

We are christians off to war
through the mud the shit the gore

We are unafraid
for we've been there before

We will save your heathen soul
that is our christian goal

We are unafraid
for we have been there before

We will blast your heathen ass
to bring you freedom liberty alas

We are unafraid
for we have been there before

We are christians off to war
through the mud the shit the gore

5-3-2005

MILITARY TIME

The recruiter promised said
we provide room and bread
sign you up for just ten years

The recruiter never told you or your peers

Your service may well extend
forever for a war that never ends
you may bitch and you may cry
if we wish we have you 'till you die

No the recruiter never told
once your in we have your soul

5 -14-2005

ALAS

Horny men alas
do make passes
at those lasses
who wear glasses

They use to
and they still do
to lasses
who still wear glasses

response to Dorothy Parker

5-25-2005

ICE FISHING

Place your hut over the hole
take your line and pole
drop your line below the ice
if you catch one that is nice
if not have whiskey over ice

5-30-2005

RELIGION

Has the answers to all things
just ask those men of god
with all their golden rings
they will tell you that their god

Works in mysterious ways
just bow down give praise
meanwhile don't make waves
in the far distant by and by
check with god when you die

6-5-2005

SCIENCE

Is to uncover and discover
the why for and wherever
that our world may be known
it's existence to all else known
that this world is not alone

6-5-2005

DISCRETION

One in five kids or one in six
spouses are out there making tricks
but wonders it does for the genetic mix

It does however put marriages at risk
call it maternal and parental misdirection's
even Adam and Eve had their own discretion's

Now Able and Cain were not the same
so one must wonder from whence they came

So even today as on TV shows
married couples often come to blows
about whoever it is that's taking tricks

6-7-2005

LOVE'S PARTING

The best part of loving
they say is the leaving
and the letting go
with the minimal of fussing
three wives let me go
each in their own way
they turned me away
and so it is I found it so

6-8-2005

SCIENCE AND RELIGION

'Tis not the winds of heaven
that trample down the pines
or blows in easy flow along the lea
but earthly winds blowing from the sea
plus water doesn't flow from smitten rock
as scientist know from their geology
and gravity is the cause of seaward flow
meteorologist know why the tempests blow
these are things that we now know

Why seek to know? why to understand
ignorance is for those who do not care
no honest toil is vain the searcher knows
that if all science were formulated prayer
the monks the priest the ministers the pope
would be mathematicians engineers of hope
and all their prayers would not get us far
to propel our rockets to the nearest star
and this is what I believe I know

Response to Ambrose Bierce on science

6-9-2005

A HORSE'S ASS

Apparently it is not a legal offense
to climb over a farmer's fence
for sex with the farmer's horse

Even less of an offense of course
if during intercourse with the horse
should the horse then take offense
raise a hoof and strike the fellow dead

The horse was not injured they said
so the horse nor the farmer made no claim
against the man of questionable fame

The paper made no mention at which end
of the horse the fellow met his own end

Bestiality in WA is not an illegal sin
but hobble the horse before you begin

An Article : Seattle Times

7-15-2005

THE MAN'S ASS

The event in Enumclaw
though well within the law
the story as initially told
was half-ass backward
as the story began to unfold
his was the horse's ass

The man cried out "What a ball
up my ass I will take it all"
so he did beyond the colon wall
as the colon ruptured so he cried
'another such orgasm I will die"
laughed and drew a long drawn gasp
the words his laugh the gasp
his very last
the infamous man he died

11-28-2005

WATER WISHES

If it is for water that you wish
don't trust a man with a willow switch
that some refer to as a water witch
better find a geologist who understands
what strata lies below your lands
and one that knows that water flows
from high mountains to the lows
but only if there lies porous sand
below the home build upon the land

7-16-2005

LINCOLN PARK

The bronze limbs
of the evergreen leafed
Madronna reflects
our modern pollution
by it's sparse foliage

While a robin
on a high branch
unaware sings
"'cheer up cheer up"
into a Seattle
bright snowless
winter's morning

The blue water
of Puget Sound
just to the west
sparkles in the sunlight

7-19-2005

CAUSE AND AFFECTS

Should you consider life a test
then learn life's lessons best
by choosing to ask questions

Know that nature's laws
are the standard cause

It is in doing not the will
of mind that will instill
a lesson to inspire
knowledge that is higher
than of the general mill

Know that nature's laws
are the standard cause

Knowledge within will shine
as great as any light sublime
and meet life's hardest test
serving you the most the best

Know nature's laws
all it's affects and cause

7-26-2005

END OF THE LINE

The shrink she inquired
"Have you ever considered suicide"
she knowing my father
his three brothers
and two step brothers
of my mother's
at various stages
of their ages
for reasons unrelated
made the decision
that it was time to go
fast by gun
or starvation slow

Oh! hell yes
definitely indeed
when living with long term pain
living seems to offer
little gain
so suicide I feel
is an option
an opportunity
at the proper time
deciding you have reached
end of the line

7-26-2005

WONDER WHY

I wonder I do declare
it seems most unfair
through seasons of reasons
I have never met a demon
never have I been a host
to an earthly ghost

Never have I trot
in the footsteps of a god
never have found myself
in the company of an elf

Would've questioned my sanity
had I bedded a lady fairy
never found myself in space
kidnaped by an alien race
how strange it is that I
am blind to what others espy

9-12-2005

FIRE DRAGON

I have entered
the burning embers
in the flaming maw
of a great dragon

To become one
with the multihued
universe of endless
changing space

10-4-2005

DAILY NEWS

I search the news
to find some positive factor
if not then one minute
new found additional fact

Found three items

The two moons of Pluto
to be confirmed shortly
in terms of light years
from earth

Four giant galaxies
found colliding
no immediate threat
to earth

A gigantic black hole
ravenously ingesting
our galaxy of stars
and eventually
earth

11-3-2005

THE MOTE IN MAN'S EYE

How over aggrandized
this dust mote of earth
that gave us birth

When within one galaxy
there lie more planets
than children who have ever
been given birth

Consider all the galaxies
within one universe
then possible planets
in a multi-universe

Now consider if you can
the significance of man
who imagines that he can
know how it all began

11-11-2005

SOJOURN

Out of dark Africa
black as my Frisco jeans
my ancestors headed north
then west east north again
in those directions toward
the unknown continent
20 to 80 thousand years ago

In hunger they followed
the beasts of forest and plains
as the heavy rains bleached
their hides and the desert
wind slanted their eyes
some became the color
of the blowing yellow sands

I am of east and west
and my unknown progeny
of variable shades of color
shall sojourn
onward and outward
to satisfy that inward
restlessness to understand
and to know the unknown
that lies beyond the unknown

11-14-2005

DARK DAYS

It is a dark day
when our leaders contrive
to balance truth with lies

It is a dark day
when our president derives
from intelligence data that lies

It is a dark day
when our leaders decide
that deception is wise

It is a dark day
when our government declares
the sanctity of torture wares

It is a dark day
when many people do not care
after all it is not their affair

11-29-2005

OPENNESS

Live with open hands
with open arms
an open heart
and an open mind
leveled with awareness

Hold no secrets
from yourself
question all beliefs
tell yourself no lies

1-10-2006

LIKE A RIVER

Anger is a raging river
love a serene stream
meditation a crystal clear pool

1-10-2006

BEING AND NON BEING

That which is not
has no being

The imagined
may be named
but naming
lends no reality
only confusion

Thus all the many
many names of god
creates no gods
ever into being
by any name

1-10-2006

GONE BEFORE ME

I shall not name
all the poets before me
now as they say
pushing up daisies
or fertilizing trees

Also fertilizing
young poetic minds
with syntax phrases rhymes
so many I carried home
and into my heart

Those enjoyed the most
were for the turn of a phrase
a modicum of humor
preferably light
that comes on slowly
almost unexpectedly
imperceptibly eliciting
a silent exclamation
"Ah!" with an inner smile
of recognition

There have been others
rarely now remembered
for being alien
to my own self
beyond understanding
as to purpose or meaning
as from some other world
or some other
intellectual culture beyond
my understanding
rendering their verse
a mystery to myself

3-30-2006

ONLY IF

If secularist agnostics and atheist
and sinful christians unrepentant
were regularly struck by lightning

If pedophiles fraudulent priests and
politicians and serial killers
were found dead without known cause

If the worst of dictators and tyrants
who commit on their own genocide
were found as suicides self brutalized

If when the leaders of all nations
promote and facilitate ever lasting peace
assist the poor the famished the sick

Then I would question my own
disbelief

4-2-2006

STATISTICS

We count carefully
the deaths of our soldiers
but less carefully
the wounded or maimed

Much less carefully
those of the enemy
soldiers citizens children
dead or maimed

Less nationally
we neglect to tally
the vehicular deaths
the wounded the maimed

As with our enemy
we avoid to tally
deaths within industry
to protect the economy

4-6-2006

THUS

The word is
the word was
shall always be

From the beginning
to the ending
the word shall be

From the first
crying of birth
to death's last cry

From the desire
of understanding
the word shall be

Speak the word
of becoming
it becomes you

You become
wholly one
with the word

Speak kindly
for the word
may flow onward

Speak carefully
that the word
may last forever

4-6-2006

CREED

Neither by night
nor by light of day
forever and ever
shall there ever be any gods
demons or angels before me
nor such images
of any religion
wherever I dwell
or on my walls
where in I live
or on my body
or on the land
or on any I call
my very own

4-14-2006

HAIR THIS

Long hair on men
according to some women
appears feminine

Short hair on women
appears most masculine
to many men

Oh! just say amen
to men and women
who care to compare
the length or another's hair.

5-18-2006

IMPOSSIBLE DREAM

I dream the seemingly impossible
that war shall be no more
while wars rage on

I dream with diminishing hope
that nations shall no more
produce weaponry of war

I dream of a hopeful possible time
when no nation shall violate
even one life of any citizen

I dream of such a future as when
compassion shall rule over greed
when the least shall be no less
than the greatest of these

I dream admittedly it must seem
the most impossible dream
when all religion is separate
from every governed state

6-11-2006

THE CHOSEN

If you see demons
hear the voices of angels
if you speak to voices
out of the blue heavens
I say you are mad

You are certainly insane
if you find yourself enraged
if others can not see
within the shadows of a tree
ominous demons you see

Don't you wonder why
have you not thought
that it is most odd
why it was that god
chose you to see what others
do not view

6-24-2006

QUESTION

Don't trust me
question yourself
question others
question all

Question the politician
question religion
question tradition

Don't trust me
question yourself

Question your faith
question your belief
question your need

Don't trust me
question yourself

7-24-2006

THE POTTER AND
THE VESSEL

You may choose
to be or not to be

You may choose
to be a warrior
or a pacifist
or any one else
or in between

Choose early
or else others
shall choose for you

Their choice
can not be your own

Truly to be you
you must choose
to be who you are

7-28-2006

LOVE LOST

When I no longer have your love
I shall no longer need your body
then should we pass each other by
it shall be as unknown strangers
who pass each other in the stream of life
toward our own individual destinies

1-10-2007

WASTE AWAY

Throughout my life
I have been a wanderer
so I have learned to allow
most anything to slip
through my open fingers
including time

"Just you wait young man
as you grow old you will see
how it is that you are wasting time"
when old we should waste some time
but especially when young

Some time just to dream
some time to relax lay back
take some time to question
what this whole life is about
surely some time to wonder
about this whole damn world
and the way of every thing

1-10-2007

SYSTEM CHANGE

Vote for the one
with the smallest fund
corporations have not paid
that person to run

Vote for women
until half our reps
are of the feminine gender
vote for any member

Agnostic atheist or secular
of every shade of color
asexual or regular
for ethical order

Fearless of god
and non susceptible to fraud

1-15-2007

INFANTILE

There are those who
would revert to
the infantile state

For a certain fee
there are special
accommodations

To suckle
a lactating nanny
to be diapered

To be swaddled
with a nippled bottle
in adult cradles

A nanny to sing
soft lullabies
soothing you to sleep

The service is not cheap
but available
check your internet

1-23-2007

LIFE IS

the loving
the knowing
the touching
the feeling
the seeing
the thinking
the singing

Death is

the ending
the remembering
by others

1-23-2007

WEATHER OR NOT

Because it rains here
it rains not every where
the skies are overcast
but drive an hour away
and the sun may shine

Or if the sun shines here
and the skies are clear
an hour away there may be
a blinding snow blizzard
creating a winter wonderland

If the weather is not to your
liking today wait awhile until
tomorrow and it may get
worst but it will surely
always change eventually

1-27-2007

PAIN

Pain is not
entirely in vain
but just the same

Endless pain
is a most
bitter pill

Pain sucks
will from
the mind

Pain drains
energy from
the body

Pain wears
the body
away

Pain kills
all there is
of desire

Pain drives
away the will
to live

Pain makes
death seem
desirable

1-26-2007

UNENDING

The truth is known
that everything changes
while most would wish
that all would remain
forever the same

Should it all remain
always the same
most would complain
with disgusted disdain

About immortality
of unending war
the consistency
of forever spring or
always winter

Of never falling in love
or never falling out of love
always the chore
of never dying
a complete and total bore

2-16-2007

TO WONDER

Three yellow birds in the wood
warbled heart fully as they could
along came a hunter
and blew them asunder
it leaves one to wonder
about three birds and a hunter

3-6-2007

YOU SEE

You see what I mean
no I can not see what you mean
for I see with a different eye

Unless you explain it to me
I can not see what you mean
and perhaps not even then

So you see what I mean

4-14-2007

NO DIFFERENCE

If you were me
or you were I
we couldn't conceivably be
either of who we are
and agreement be as far
as just being who we be
just the way we are

If you stand here
and I stand there
you see all we've done
is stir the air

4-14-2007

DEATH

Driving north on 405
between Seattle and Bothell
on a dark drizzly day

I was passed by a large
black and chrome Buick
20 years prior in vantage
the windows darkly tinted
no one visible within
the license plate read
DEATH

I drove carefully
kept my distance

5-16-2007

MY LIFE

At fifteen I felt trapped
by the atmosphere
or a provincial family
and a small community
both poor

Where did not matter
one country or another
one ship to another

From the great Lakes
to the Pacific
moving west then east
north to south

One school to another
one state to another
then west again

From one wife to another
then a third
all left behind

Moving on
this city that city
each place a home

Until dissatisfaction
moves in
and I move on

I am still moving on
preparing for that
last move

5-19-2007

EVOLUTIONARY

You only need to use your eyes
to relies
that any two of anything
are never entirely alike

Bring any two together
to form a third
and that member
will never be entirely
alike the former two

Which illustrates
an evolutionary view

6-6-2007

MATERIALISM

If my bowl is chipped
I consider it used-ware
I prefer my bowls whole
but will use it until
cracked or fractured
not unlike some persons
of acquaintance
I keep at a distance

Some may consider
it not masculine
I replace lost buttons
or mend old shirts
as material outwears
the decade worn threads
these shirts are so familiar
out of current fashion
like my ancient friends
I cherish them all

Cars I treat similarly
aged and not expensive
no younger than a quarter
of my own advanced years
preferred with manual gears
and operating on less fuel
and needing less attention
than myself personally
while getting me safely
wherever

6-26-2007

LIES THEN WHOPPERS

Stop your crying
or the boogie man
will get you
be very good
or Santa Claus
will pass you by

Don't cry
the tooth fairy
will exchange your tooth
for a dollar

Don't play
with yourself
hair will grow on your palm
or you will get zits
then everyone
will know

Go to church
and pray
or when you die
you will find yourself
in hell

In your twenties
the evil dictator
has the bomb
you must destroy
that monster

If you don't
go to war
we will watch your ass
and the rest of you
as a suspect
as a possible traitor
and that may
not be a lie

6-26-2007

HALF THE MAN

You're fortunate to have legs
to hold that enormous gut
if it weren't for those legs
you just might roll down hill
and never be able to return

Without that belly of yours
you would be less than half the man
most friends would not recognize you
or wonder where the other half of you
had gotten up and left

That good stalwart women of yours
waking up in bed finding only half
the man she thought she wed
might think herself gone daft
to find a skinny stranger in her bed

6-27-2007

PRIMARY

human need

air to breath
sufficient food
various liquids

freedom to speak
ability to think
love joyfully
excrete privately
sleep peacefully

millions of atheist
would not exist
if myths were indeed
a primary human need

8-10-2007

IF ONLY

If prayers could heal
then thoughts should kill
yet tyrants prosper still

Dictators proliferate thrive
while the citizenry strive
to keep body-mind alive

If only thoughts would kill
then the citizenry could will
that tyrants lie stiff and still

8-28-2007

GIRLS & BOYS

Girls will be girls
and boys will be boys
to play with each other
as sexual toys

Some girls would be boys
some boys would be girls
and try with each other
to find sexual joys

Girls will be girls
and boys will be boys
to seek with each other
to be sexual foils

9-24-2007

CONTACT

Being alone
doesn't have to be
lonesome

It need not
be quiet
or silent

Conversation
is limited
unless you talk
to yourself

Today
the radio
television
computer
can entertain
you

Or drive you
mad enough to call
random numbers
on your cell
phone

Impose
upon a friend

In desperation
call the police

No don't do that
they might
accidentally
shoot you

Prior to verbal
contact

Don't answer
the door
with your cell
in hand

It may be construed
as a weapon

9-27-2007

? WHERE TO ?

For as much as
you believe
I disbelieve
for a thousand
reasons why
from before time
that Adam and Eve
climbed down
from the tree

Do not take
Adam and Eve
literally
or other myths
of antiquity

Just name me
all the gods
of existence
before the rise
of humankind
if you
do not mind

I say
I disbelieve
for that is what you
prefer to believe

But I do believe
not in religion
or superstition
but what reason
can perceive from
nature alone
from within our
own being
and outward
to the furthest
of stars

Those
who have power
would keep you
in ignorance
for their own
sake

Look about you
and weep
for the world
is at stake

10-3-2007

ALL THE SAME

"to thine own self be true"
Shakespeare

Be proud
but not unkind

Bow you not down
to any being

Nor to any craven image
worldly or unworldly

We are all of the same
substance made

Only variations
of the same differentiation's

10-11-2007

THUS

"things are what they are"

Fernando Pessoa

And nothing more
nothing is hidden
all things are only
there to be found
mankind to discover

Lend me you
electron ears
radio telescopes
instruments of space
of inner space
artificial intelligence

These and the uninvented
shall expand knowledge
beyond the imaginable
forever within the factual
the actual of existence

10-29-2007

NO MIND

Nature does not know itself
and it does not care
it does not think at all

For nature does not have
the where with all to think
It has no purpose to be

Only the purpose we assign
erroneously for it has no care
no wish no goal but just to be

It has no care no mind
to be concerned with itself
or with the likes of us

10-30-2007

A PIN POINT

Earth while dead or alive
shall be your only home
that you can call your own

Until we inhabit the moon
perhaps even mars
or further still the stars
until some distant time

The entire vast universe
may turn into reverse
and turn all we know to be
into a pin point of energy

11-3-2007

AWAKE

All of the holy books
none are of the gods
but the creations of old men
bent by high ambitions
to protect their positions
for herding and controlling
the anarchic multitudes

These unholy books are
eastern Indian bhagava gita
the Hebrew torah the kabala
the old testament of the Jews
the christian new testament
the Muslim koran
the Tibetan book of the dead
the book of mormon
dyanetics science fiction
even the mafia have
their own ten commandments

All the above books
hold less of truth
than the daily world news
the New York Times
the Post Inteligencer

These books are less current
and no less violent
than the news which offers you
no prizes beyond this world
or any other impossible existence
but beware for they too
may offer you propaganda
may promote ancient mythology
the same old game

11-9-2007

BECOMING

When young
in order to leave home
I became a wanderer

I became a seaman
to see more of the world
than hitch hiking on highways

I became a geologist
because I found rocks
more stable than people

I became a hydrogeologist
for water flows and conforms
to the strict laws of physics

I became a jewelry craftsman
of gemstones silver and gold
for jewelry is seldom used to kill

Growing older I became a poet
as yet of no great note
expressing concepts of hope

11-11-2007

MOVING ON

There are no jack assess
nor elephants on my shelves

Once when young I was offered
the occupation of caregiver
of elephants I declined

Being a member of current society
at any level was circus enough

So I continued down life's highway
garnering about me what it was
I would haphazardly become

Without guilt or anxiety
at least for no longer than
it took to consider the consequence
and possibilities then moved on

As an elder I seldom consider
donkeys or elephants as relevant
to my diminishing existence

Within my own personal fantasies
I allow the world out there
to either screw up or take care of it's self

There are at least times I pretend
that I really do not care
about those who die from constant
conflicts and forever unending wars

11-11-2007

ONE TEDDY BEAR

If there be
but one thing
that is holy
then let that be
human life

Not gods
not the ground
upon which we stand

Not religion
or it's edifices
churches or mosques

Nor for prophets
jesus or mohammed
not by teddy bears

But only for life
human life
of more value
than all the gods

One teddy bear
named mohammed
is not worth one life
or fifteen days
in jail

So much for
religious bigotry
ignorance and education

12-1-2007

THE PRIM ROSE PATH

Never shall they draw me
down the prim rose path
for I have been had it too
many different ways

No more shall I bend over
regardless of temptations
the red sports vehicle
with the dashing blond
poured in a mini bikini

Not for all the favors
of the angels of heaven
nor a lounge chair
on the right hand side
of the grand old man

My faith lies only in
the liberation from dogma
not threatened or tempted
by the glories of heaven
nor the damnation of hell

12-19 2007

CHANCE RULES

Fundamentalists have assigned
the concept of intelligent design
to the entire universe
not recognizing a decline
of a diminishing divine
while chance rules the universe

1-2-2008

WHY WOULD

Why would a woman
tell a man
that she had loved a woman
or why would a man
tell a woman
that he had loved a man

If the woman
had interest in the man
or if the man
was interested in the woman

I fail to understand
the intentions of their plan
unless they intend to demand
a three way stand

1-17-2008

CELLULAR EXCHANGE

The matter that was you
of your yesterday
is not the matter of you
as you are today

But even so the memory
of your long yesterdays
have not changed materially
from those you hold today

If all the matter of yesterday
that were you has changed
how is it that your memory
of old has been retained

1-18-2008

SYNCHRONICITY

There is no good
or bad luck
there is no luck at all

Only coincidence
the coincidence
of being
in the wrong
or the right place
during an occurrence
that may do you
good or ill

In most situations
look both ways
before you leap
or invest your funds

If you collide
with a locomotive
it is no luck at all
only lack of attention

Timing is said
to be everything

1-20-2008

NAKED

Most every day
I walk out in public
naked under my clothes

No one seems to notice
so to get attention
I spill out some words
so some may see inside
of the out side of me

Few are interested
some shy away
others get angry
but seldom rarely
do they threaten me

Some draw the line
when I question the divine
saying if they had a a gun
it would give them fun
just to blow me away
no intended animosity
but to please the almighty

At times I am surprised
at the possibility of my demise
but I tuck in my shirt
straighten my non existing tie
then wish the disturbed
the very best of day
and amble on my way

1-23-2008

MODIFICATION

Less than mighty
we are less
than might be

We may become
much more
as we change the world

So the world
will mold and change
humankind

As we modify
our environment
we shall be modified
for good or ill

The universe
may ultimately destroy
humanity

Meanwhile nature
may grant us
an earthly paradise

Should that be our desire

2-13-2008

CHOICES

Some like white meat
some like dark meat
I like mine lean clean
and in between

3-4-2008